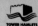

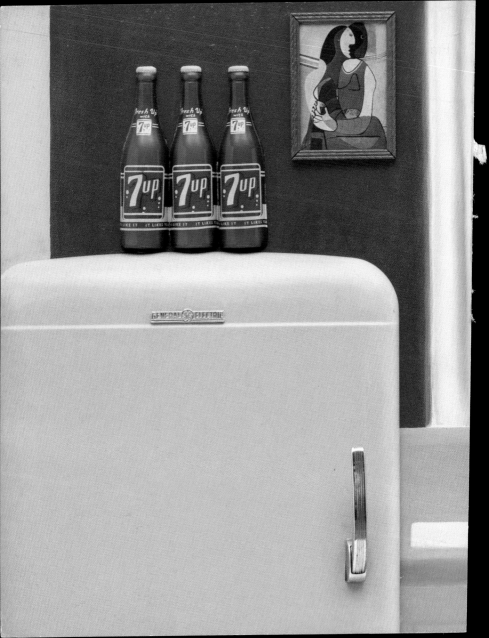

Flaminio Gualdoni

POP ART

SKIRA

front cover
Roy Lichtenstein
Yellow and Green Brushstrokes
(detail), 1966
Oil and magna (acrylic)
on canvas, 214 x 458 cm
Museum für Moderne Kunst,
Frankfurt

facing title page
Tom Wesselmann
Still Life #30 (detail), 1963
Oil, enamel and synthetic polymer
paint on composition board with
collage of printed advertisements,
plastic flowers, refrigerator door,

plastic replicas of 7-Up bottles,
glazed and framed colour
reproduction and stamped metal,
122 x 167.5 x 10 cm
The Museum of Modern Art,
New York
Gift of Philip Johnson

Skira editore
SkiraMiniARTbooks

Editor
Eileen Romano

Design
Marcello Francone

Editorial Coordination
Giovanna Rocchi

Editing
Maria Conconi

Layout
Anna Cattaneo

Iconographical Research
Alice Spadacini

Translation
Christopher "Shanti" Evans
for Language Consulting Congressi,
Milan

First published in Italy in 2008
by Skira Editore S.p.A.
Palazzo Casati Stampa
via Torino 61
20123 Milano
Italy

www.skira.net

Printed and bound in Italy.
First edition

ISBN 978-88-6130-736-0

Distributed in the US and Canada
through Rizzoli International
Publications by Random House, 300
Park Avenue South,
New York, NY 10010.
Distributed elsewhere in the world by
Thames and Hudson Ltd., 181
a High Holborn, London WC1V 7QX,
United Kingdom.

Contents

Pop Art

January 1958. A solo exhibition by Jasper Johns opened at Leo Castelli's gallery in New York, followed, in February, by an exhibition of Robert Rauschenberg. Pollock had died dramatically just over a year earlier, and the international art scene had changed drastically. Many sought to identify the character of the new artistic climate as a revival of Dadaism, resulting in the coining of the term New Dada, but it was an English critic, Lawrence Alloway, who first sensed the underlying reality of the new form of art.

In an article that came out in *Architectural Design* in that same February of 1958, significantly entitled "The Arts and the Mass Media", he spoke of a culture made up of banal images linked to mass consumption, stereotypes and simplifications, in which merchandise had more importance than objects of art and comic strips communicated more effectively than novels: this was "mass popular art", which had assumed a far more dominant role than "high" and official culture. Pop Art was the art that was born out of this situation, it was popular culture constructing its own monuments. Rauschenberg exhibited his "combine-paintings", works to which he applied photographs, fragments of advertising images and above all actual objects taken from ordinary life, such as an umbrella or a car tyre, a bottle of Coca-Cola or a stuffed animal. These objects were introduced into works dripping with paint in bright colours, executed with a cursive and brusque technique that in some ways recalled that of the immediately preceding current of Action Painting. So they were still pictures, but at the same time three-dimensional assemblages in which the banal object was presented for what it was, a scrap of everyday life inserted into a work of art. The result was in some ways shocking, because it was the first time that things and images taken from

daily reality had been included within a pictorial procedure with such indifferent brutality, but it was an act that brought the pictures to life. It had some paradoxical effects: the MoMA, the Museum of Modern Art in New York, temple of the historical avant-garde, initially turned down donations of works from the artist because they were made out of perishable materials whose conservation it was unable to guarantee.

In other ways Rauschenberg's works fell within a tradition that was familiar to the avant-garde of the 20th century: from the Cubist collage, which entailed the insertion of existing images into the fabric of the painting, to the Dadaist ready-made, which manipulated concrete objects; from the creations of Kurt Schwitters, which turned things drawn from reality into pictures, to those of the Surrealists, from Max Ernst to Joseph Cornell, in which objects were transformed into elements of complex and paradoxical visual situations; from the work of Francis Picabia, who reutilized popular images in his iconographic montages, to that of the Americans Stuart Davis and William Copley, the former author since the twenties of pictures representing commercial packages and advertising images, the latter a follower of Surrealism who was influenced by the comic strip in the fifties and chose themes like State emblems and flags.

Rauschenberg was considered the great synthesizer of these precedents, and the assignment of the Grand Prize to him at the Venice Biennale in 1964 would proclaim him, to all intents and purposes, as the father of Pop Art. The case of Jasper Johns is very different. He painted in slow, detached, precise strokes, with great

Bernard Rancillac
The Last Whisky
(detail), 1966
Vinyl paint on canvas,
225 × 200 cm
Musée d'art moderne,
Saint-Etienne Métropole

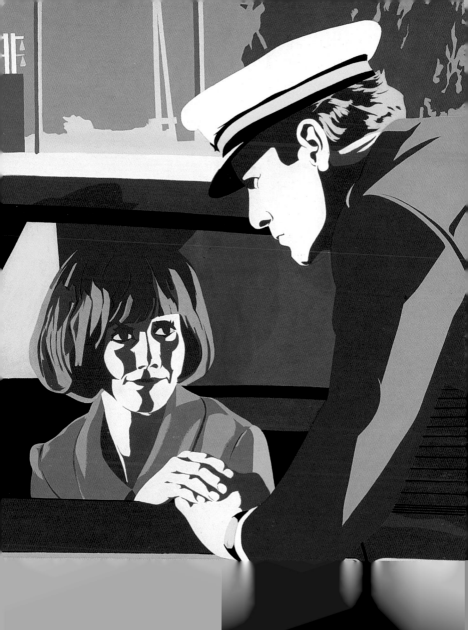

accuracy, resorting to long-established techniques like encaustics, used by the ancient Romans, and glazing to produce pictures of a traditional size. But his subjects were the American flag, shooting gallery targets and numerals, i.e. schematic and stereotyped images that had no other significance than their vividness. Instead of contaminating and dissolving the common idea of painting from the technical point of view, he chose to ennoble banal icons through the use of the most sophisticated techniques of painting, in a sort of metaphysics of the commonplace. Perhaps partly as a consequence of the ease of identification of his works, which did not present any problems from the perspective of execution, he was considered from the outset the "new Pollock" of American art: his obvious technical skill, and the fact that his forerunners were artists like Davis and Charles Demuth (who had also devoted a series of paintings to numbers), which meant that unlike Rauschenberg he drew his inspiration from the indigenous tradition rather than from the European one, made him the perfect "100% American" artist: something which at that moment, when the USA wanted to add cultural pre-eminence to its political and economic dominance, was considered a fundamental factor. It is no coincidence that the MoMA acquired four works by Johns on the very day his exhibition opened at Castelli's gallery, and that it was one of his works, now in the Whitney Museum in New York, that was first sold at the symbolically significant price of a million dollars. Johns had tackled the subject of the flag in 1954, and in the first half of the fifties Rauschenberg was already evolving from his own roots in Dada and Surrealism. The fact is that, even before the boom of the sixties, Pop Art had had, like all avant-garde movements, a series of harbingers and germinal experiences. These oc-

curred not just in the USA, acknowledged home of the movement, but also, and in a far from marginal way, in Europe. It is no accident that an exhibition by the brilliant Italian set designer and illustrator Domenico Gnoli in New York in 1956 is considered an important stage in the development of Pop Art.

In the early fifties the Independent Group, an association of intellectuals who reflected on modernity and its images in various ways, was active at the Institute of Contemporary Art in London. The artists Eduardo Paolozzi and Richard Hamilton, the architects Alison and Peter Smithson and the critic Lawrence Alloway staged exhibitions at the ICA like *Parallel of Life and Art*, 1953, and *Man, Machine and Motion*, 1955, followed the year after by *This Is Tomorrow* at the Whitechapel Gallery. They were made up of photographs, montages and installations that examined the grand themes of the contemporary imagination: photography, technology, advertising, merchandise, machinery. The new British painting, announced by the exhibition *Young Contemporaries* at the RBA Galleries in London in 1961, was born in this milieu, with the emergence of an authentic Pop generation that included such outstanding artists as Paolozzi, Hamilton, Richard Smith, Peter Blake (who was to design the legendary sleeve for the Beatles' album *Sgt. Pepper's Lonely Hearts Club Band* in 1967), Ronald B. Kitaj, Peter Phillips, David Hockney, Joe Tilson, Bernard Cohen, Allen Jones and Patrick Caulfield. Phillips was to write in 1964: "My awareness of machines, advertising and mass communications is not probably in the same sense of an older generation that's been without these factors... I've lived with them ever since I can remember and so it's natural to use them

11

without thinking." In the same years something similar was going on in Parisian circles. On show at the first Paris Biennale, in 1959, were a monochrome by Yves Klein, one of Jean Tinguely's "painting machines" and a hoarding with torn posters by Raymond Hains. It was the beginning of what was to be dubbed Nouveau Réalisme ("New Realism") by the critic Pierre Restany a year later, presenting the movement in an exhibition at the Galleria Apollinaire in Milan and, in 1961, in the Parisian exhibition *A 40° au-dessus de Dada* ("40° above Dada"). While Klein's monochromes explored a sort of metaphysics of colour, Tinguely's noisy and useless machines, like the works of Hains, Arman, Jacques de La Villeglé, François Dufrêne, Mimmo Rotella, Daniel Spoerri, Martial Raysse, César, Niki de Saint Phalle, Christo and Gérard Deschamps, brought about what Restany defined as a "poetic recycling of urban, industrial and advertising reality", i.e. the reutilization of mechanisms, objects and shreds of images drawn from everyday life and their reinvention in different ways.

The expression Pop Art had not yet caught on and the definition coined by the French critic appeared at first to prevail, since interpretations of the time were inclined ed to view these artists more in terms of their tendency to reuse the materials of the civilization of merchandise in an inventive fashion than in those of the celebration of mass imagery. In the exhibition *Le Nouveau Réalisme à Paris et à New York* staged at the Galerie Rive Droite in Paris in 1961, American artists showed alongside the French group. Among them were Rauschenberg, Johns, Chryssa, Richard Stankiewicz and John Chamberlain, whose sculptures made from crushed automobile parts were very close to the works of César: a

"Business art is the step
that comes after Art.
(…) After I did the thing called 'art'
or whatever it's called,
I went into business art."

Andy Warhol

sign, this, that the new creative climate was by now international in character. The developments in Paris had a strong influence, at this moment, on the New York milieu: in the same year the exhibition *The Art of Assemblage* at the MoMA presented the French Nouveaux Réalistes alongside artists from the United States like Edward Kienholz, Robert Moskowitz, George Brecht and Lucas Samaras, while the following year *The New Realists* exhibition at the Sidney Janis Gallery in New York seemed to have set a definitive seal on the name and destiny of the movement. The most innovative research conducted in New York appeared at that time to have characteristics linked more closely to the birth of the happening, the installation and the performance than to the ones that Pop Art was to emphasize.

Claes Oldenburg and Coosje van Bruggen
Mistos (Match Cover) (detail), 1992
Steel, aluminium and fibre-reinforced plastic, painted with polyurethane enamel, 20.73 × 10.06 × 13.21 m
La Vall d'Hebron, Barcelona

Allan Kaprow had already set an example with his *18 Happenings in 6 Parts* at the Reuben Gallery in 1959, ushering in the art of performance which physically involved author and public.

At other "off" venues like the Judson Gallery, Claes Oldenburg, Jim Dine and their fellow experimenters created three-dimensional settings they called environments: *Environments, Situations, Spaces* was the title given to a major exhibition staged at the Martha Jackson Gallery in 1961, with artists come Brecht, Dine, Kaprow and Oldenburg.

Among the more sensational events of the period was Oldenburg's *The Store*, which in 1961 presented mock products in a real abandoned shop on the Lower East Side, filled by the artist with 120 sculptures representing objects for sale along with their prices. Oldenburg wrote: "I am for the art of (…) red and white gasoline

pumps. I am for the art of bright blue factory columns and blinking biscuit signs. (…) I am for Kool-art, 7-UP art, Pepsi-art, (…) 39 cents art, (…) 9.99 art (…)."

A year later the scenario had completely changed, through the work of artists who bore the names of Roy Lichtenstein, Tom Wesselmann, James Rosenquist, George Segal, Claes Oldenburg, Robert Indiana and Andy Warhol. After Johns and Rauschenberg, Leo Castelli launched Lichtenstein, who chose the iconography of the cartoon strip and commercial art and blew it up out of all proportion, transferring it onto canvas without aesthetic interventions and handling the paint in a dry, uniform manner, as similar as possible to the inking used in popular publishing and even reproducing the half-tone dots.

Claes Oldenburg
and Coosje van Bruggen
Balancing Tools (detail), 1984
Steel painted with
polyurethane enamel,
8 × 9 × 6.05 m
Vitra International AG, Weil
am Rhein, Germany

In 1962 the Green Gallery staged exhibitions by James Rosenquist, George Segal, Oldenburg and Tom Wesselmann. Rosenquist, a sign painter and illustrator (Lichtenstein and Warhol also came from the world of commercial art), adapted a gluey medium used for billboards to represent fragments of images drawn from advertising and daily life on a giant scale, often on transparent supports. Segal, closer to the world of happenings and New Dada, placed plaster casts of real people in settings resembling the ones they lived in, or that were created out of physical objects, in a sort of ambiguous and disquieting theatre in which the roles of reality and representation were deliberately exchanged.

His figures inhabited situations that had much in common, in their silent anonymity, with contemporary avant-garde theatre and the world of happenings, which had abandoned traditional perform-

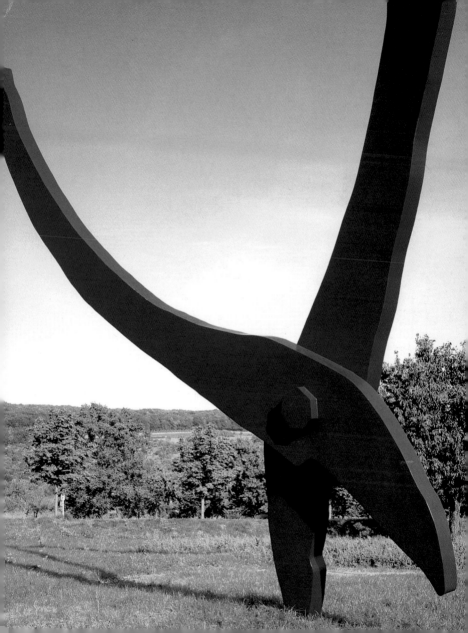

"(…) You can be watching TV
and see Coca Cola, and you know that
the President drinks Coca Cola,
Liz Taylor drinks Coca Cola,
and just think, you can drink Coca
Cola, too. A coke is a coke
and no amount of money can get you
a better coke than the one the bum
on the corner is drinking. All the cokes
are the same and all the cokes
are good. Liz Taylor knows it,
the President knows it, the bum knows
it, and you know it."

Andy Warhol

ance venues to blend in with real life. Oldenburg, who had started out with happenings of a markedly theatrical and ornate character, moved on from the reconstruction of objects and food in *The Store* to their reproduction on an exaggerated scale and in shiny, vulgar colours drawn from the best tradition of the kitsch, in soft or bleakly stiff materials: from slices of cake to cigarette butts, from typewriters to sanitary appliances, from work tools to cosmetics. Wesselmann inserted images in settings made up of objects, always on a plane of extreme banalization. Painting among things, things in painting: his work was always located on the boundary between what the observer was accustomed to consider art and what he called "ordinary life". At another innovative venue, the Stable Gallery, which shared the role of talent-scout with the Green Gallery, Robert Indiana showed large paintings conceived as signs, with harsh verbal inserts (*Eat, Die*), represented with a slickness of colour not unlike that of contemporary abstract painters like Ellsworth Kelly. After a solo exhibition at the Ferus in Los Angeles with faithful reproductions of Campbell soup cans, Andy Warhol made his New York debut at the same gallery, presenting enlargements and serial repetitions of common articles, such as Coca-Cola bottles, or silk-screened portraits of celebrities like Marilyn Monroe.

Towards the end of 1962, in the exhibition *New Realists*, Sidney Janis turned the relationship between Europe and the USA established by the earlier exhibition in Paris, based on an emphasis of the experimentalism and Dada implications of the new lines of research, on its head by showing a group of European artists like Arman, Christo (who not long before had presented a heap

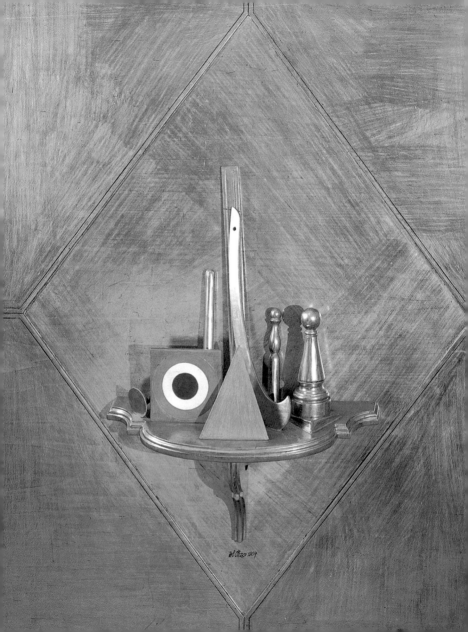

of cans at the Galerie J in Paris), Hains, Klein, Raysse, Spoerri, Tinguely, Enrico Baj, Rotella, Gianfranco Baruchello, the young Tano Festa and Mario Schifano, Peter Blake, John Latham, Peter Phillips and Öyvind Fahlström alongside Dine, Indiana, Lichtenstein, Oldenburg, Rosenquist, Segal, Warhol, Wesselmann, Moskowitz, Wayne Thiebaud and others.

It was an exhibition that did not set out to establish affinities, but differences. European art tended to take an intellectual and critical approach. American Pop Art on the other hand worked on the plane of a monumental and detached emphasizing of the object and the imagery used by advertising, of a deliberate and extreme vulgarization of the practice, once considered noble, of art. The new works icily took icons of banality, representing them on a gigantic scale and assigning them commonsense values, without alienating them. They did not just use the image of mass communications, but even adopted its standards, indifferent to the effect of cold mortality that derived from this, under the gleaming and eye-catching appearance of the object, in painting. From the moment American Pop Art was given official status, with the exhibition *Pop Art USA* at the Oakland Art Museum in September 1963, it was clear that the aspect of parody and criticism typical of the European avant-garde had been transformed into a sort of impersonal recording of images, without emotions and without alterations of quality: they were what they were, they had nothing to communicate but their own existence, and the artist reproduced them while keeping the contribution of technical skill, the "artistic" aspect, to a minimum, or even reducing it to the point of ir-

Lucio del Pezzo
Grande quadro d'oro
(*Large Gold Picture*), 1964
Acrylic and gold leaf
on wood, 162 × 130 × 40 cm
Giorgio Marconi Collection,
Milan

Martial Raysse
Yellow Nude (detail), 1964
Acrylic and oil on plywood,
96.5 × 130 cm
Luigi and Peppino
Agrati Collection

relevance. Whereas Dine and Segal, like Johns and Rauschenberg, still displayed a concern for a lucid redefinition of the creative attitude, what prevailed in the others was the strategy of utilizing the artistic context as a vehicle for the purely promotional amplification of a practice that fed on the same humus of stereotypes and language with a high degree of immediate comprehensibility as did the advertising industry. It is no coincidence that many critics have pointed out that Pop Art is the only one of the historic avant-garde movements to have been a success with the public and the media before being accepted by the experts and the world of art, and it was Lichtenstein who made it clear that "the things that I have apparently parodied I actually admire". Pop Art was the perfect art for pop culture, and pop culture, the straightforward one of the numerically dominant masses, can be recognized immediately. They loved these pictures because they loved their subjects, because they loved advertising and merchandise, or as Oldenburg would put it, "39 cents and 9.99 dollars".

Pop artists brought to the rigours and purities of the art world a vitality that was vulgar and domineering but devoid of snobbism, and one which lucidly substituted for the "highbrow" American identity sought in Action Painting the mediocrity of the middle class, the slovenly pride of recognizing one's own cultural roots in a panorama of images of consumer goods. The genius who proved capable of grasping the more profound implications of pop culture was without question Warhol. His talent lay in not seeking to put any talent into the creation of works, but adapting the mechanisms of the star system, which dominated the culture of the mass-

"I am for the art of (…)
red and white gasoline pumps.
I am for the art of bright blue
factory columns and blinking
biscuit signs. (…) I am for Kool-art,
7-UP art, Pepsi-art, (…)
39 cents art, (…) 9.99 art (…)."

Claes Oldenburg

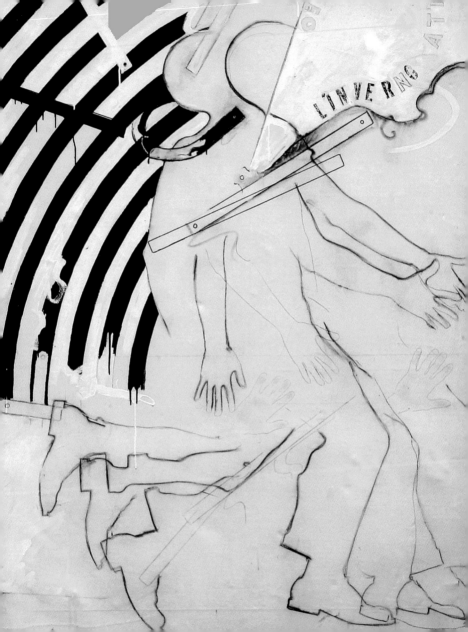

es, allowing them to dream, to the world of art. If Picasso, in the first half of the century, had succeeded in becoming the symbol of the historic avant-garde by virtue of his incomparable gifts, an unfailing cultural lucidity and a tireless prolificacy, Warhol deployed equal talent, equal lucidity and equal tenacity in becoming the most famous artist of the second half: in short he understood that, in the new culture, it was not a question of being regarded as the new Leonardo, but of becoming the new Marilyn Monroe, a living Coca-Cola. These had become the subjects of art because they were the new myths,

of which the artist could make himself high priest, to the point of becoming a myth himself. Warhol's strategy, therefore, was to be recognized as an artist irrespective of the recognition of his artistic value and not as a consequence of it. If, he reasoned, a long and demanding apprenticeship with uncertain results in the end did nothing but admit the artist into the realm of the star system, as had happened to people like Picasso, Dalí and Miró, then why not adopt directly the methods of the marketing of image that governed that star system? And if the destiny of the works of great artists was to be turned into icons of an advertising type reproduced in millions of copies, as had happened to Leonardo's *Mona Lisa* or Picasso's *Guernica*, then you might as well make sure from the outset that this could take place as smoothly as possible, by choosing as subjects images that were already part of that world.

It was Warhol who argued, with the genius of a copywriter, that the artist did not have to possess any technical ability, that he was wholly indifferent to the images he created, and that the only units

27

of measurement of the value of art were the fame that it bestowed on its author, so that he was treated on a par with the stars of rock music or the movies, and its economic value, capable of guaranteeing the respect and appreciation of all. "Business art is the step that comes after Art", wrote Warhol. "After I did the thing called 'art' or whatever it's called, I went into business art." And if art had also been assigned an ethical value, that of teaching or example or testimony, the new watchword would be amorality, indifference to any expectation that the work ought to carry a message. The artist gathered images from glossy magazines and articles from the supermarket in order to become a glossy image himself, a mass product whose trademark was the philosophy of the trademark itself. In this way the concept of a specific and autonomous value implicit in the practice of art was completely overturned. Everything was disvalue, in itself, and acquired quality only when it was capable of winning attention and publicity by worldly mechanisms. So the world of art was in turn a convention established and accepted from a purely sociological and media viewpoint: the difference between a Campbell soup can bought in a shop and a Campbell soup can signed by Warhol was a value assigned on the basis of parameters that took no account of its objective and conceptual nature, but only its social and conventional recognition. In fact that is exactly what happened. The MoMA straightaway bought works by Indiana, Warhol, Oldenburg, Wesselmann, Thiebaud and Marisol, and so did major collectors. Their prices rose quickly from a few hundred dollars to the 7,500 paid for a Rosenquist in 1963 (causing a stir in the press) and the 60,000 for a Warhol in 1970. This made news, making the art of merchandise the perfect cultural commodity.

Other exponents of Pop Art, from Allan D'Arcangelo to Red Grooms, from Richard Lindner to Robert Watts, from Richard Artschwager to Alex Katz and from Chuck Close to Mel Ramos, achieved no less success and international fame than those of the early members of the movement. Naturally all this made American Pop Art very different from the otherwise similar experiences on the other side of the Atlantic. On the whole the great European Pop artists, from Hamilton to Jones and from Hockney to Schifano (the outstanding Italian talent of a generation that also included figures like Franco Angeli, Pino Pascali, Valerio Adami and Lucio Del Pezzo), did not renounce a quest for quality and above all for the specific value of the work of art. Pop, for them, was not an elimination of all qualitative and intellectual aspects from painting. Rather it was an evolution, and one that in any case did not want to turn its back on the history of art, and on the idea itself of art that tradition had handed down. Moreover in Europe it would be more the Neo-Dadaist current identified in Nouveau Réalisme, and the evolution of the work of the earlier Surrealists, that acted as a guiding thread for the new experiences.

• Mass • Images of consur
Reinvention • Merchandise
Marketing • Parody • Standard
• Glossy • Emphasizing •
Reproducibility • Machine
Mediocrity • Ordinary life • B
• Trademark • Print • Amplific

goods • Collage • Kitsch •
Stereotype • Advertising •
communication • Vulgarization
mic strip • Assemblage •
hotograph • Banalization •
ess • Graphics • Technology
on • Star system •

Works

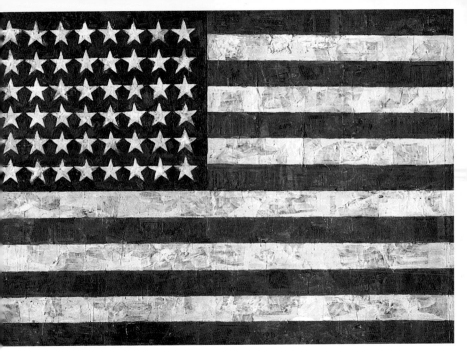

1. Jasper Johns
Flag, 1954-55

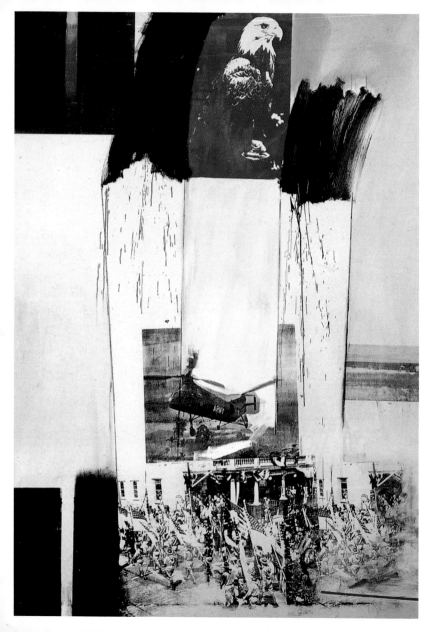

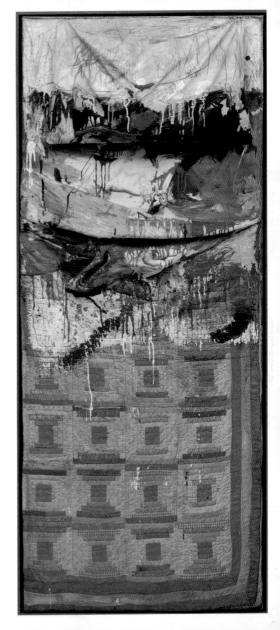

2. Robert Rauschenberg
Kite, 1953

3. Robert Rauschenberg
Bed, 1955

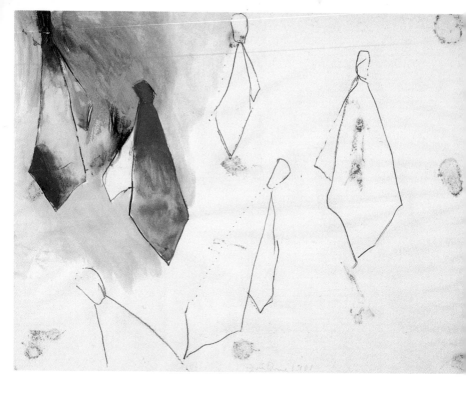

4. Jim Dine
Ties, 1961

5. Robert Rauschenberg
Blue Exit, 1961

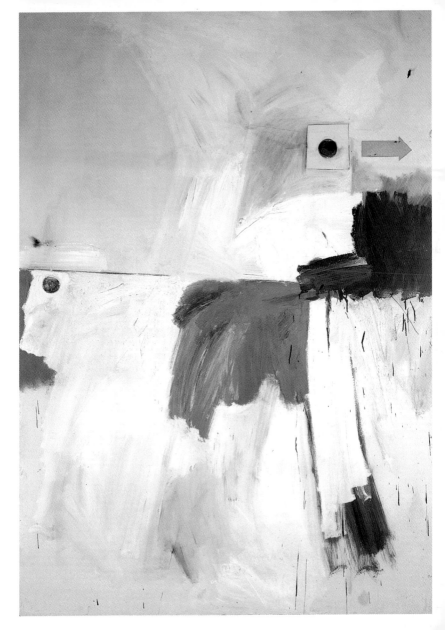

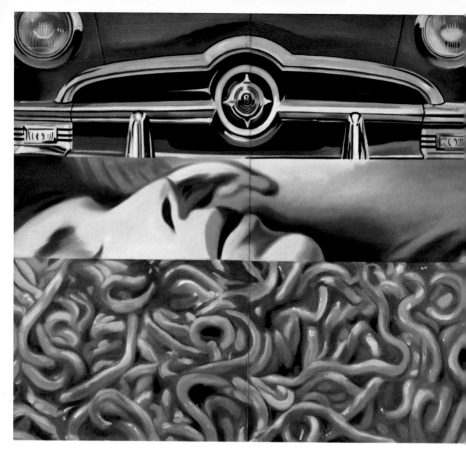

6. James Rosenquist
I Love You with My Ford,
1961

7. James Rosenquist
Blue Spark, 1962

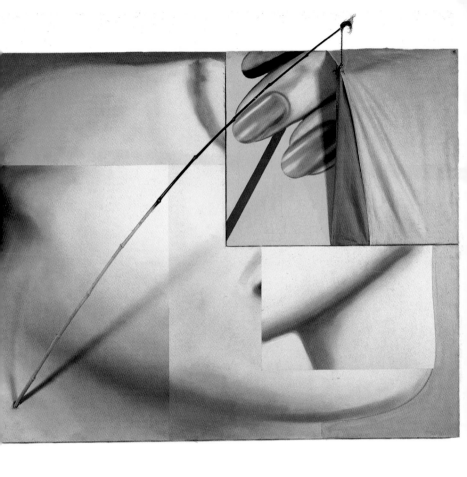

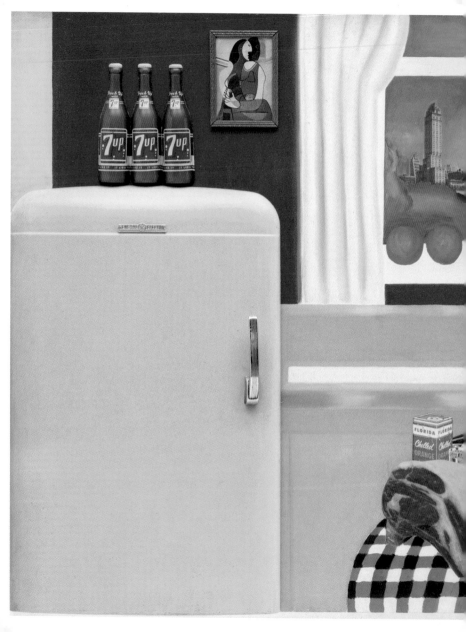

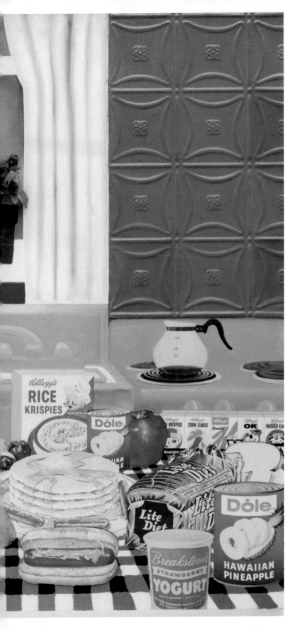

8. Tom Wesselmann
Still Life #30, 1963

Following pages
9-10. Robert Indiana
Eat/Die, 1962

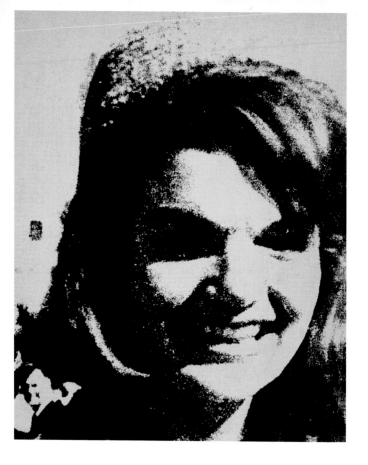

11. Andy Warhol
Jackie, 1964

12. Andy Warhol
Four Marilyns, 1962

Following pages
13. Tom Wesselmann
Mouth, 7, 1966

14. Claes Oldenburg
Lipstick (Ascending)
on Caterpillar Tracks
(detail), 1969-74

44

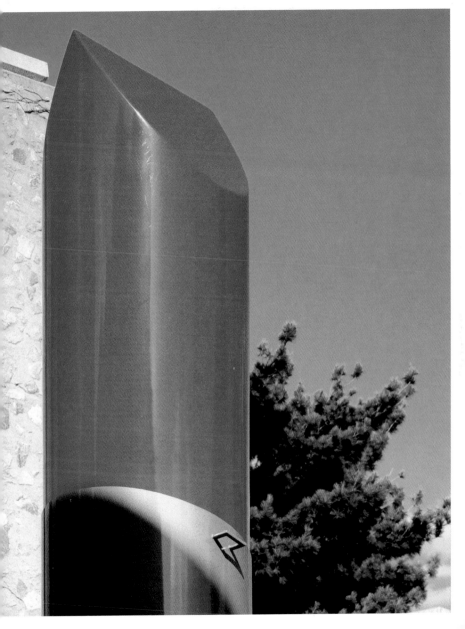

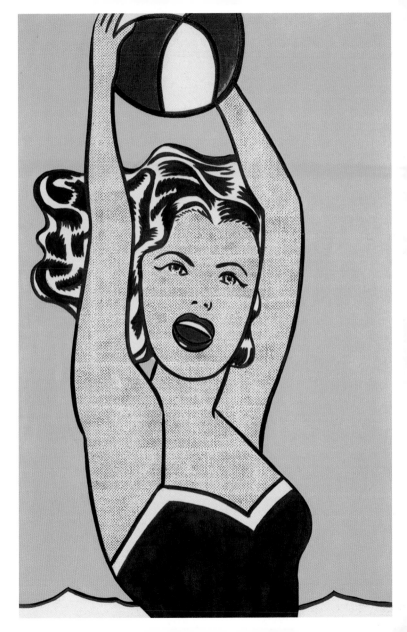

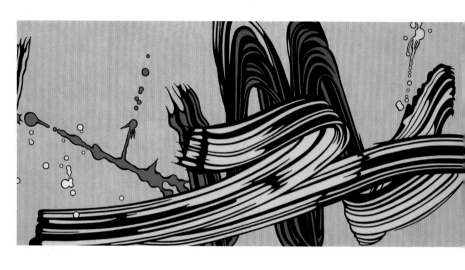

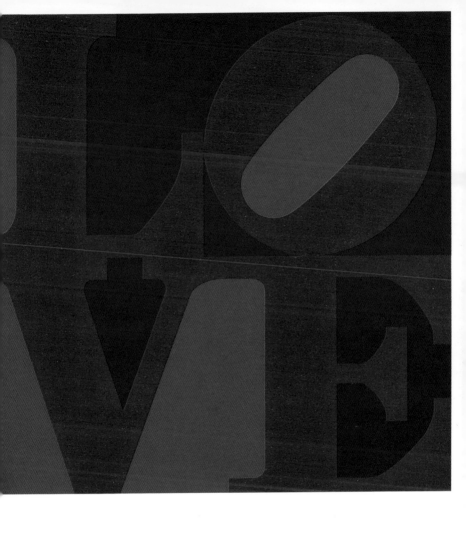

51

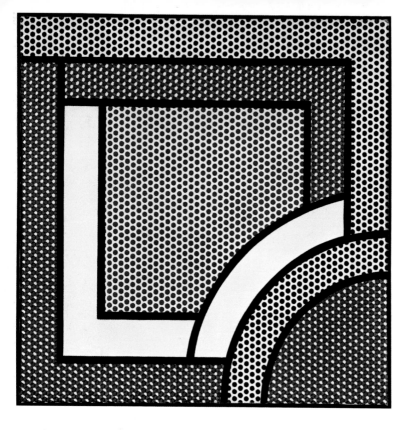

19. Roy Lichtenstein
Modern Painting; Mochen Pointiny, 1967

20. César Baldaccini called César
Compression "Ricard", 1962

Following pages
21. Jacques de La Villeglé
Avenue de La Motte-Picquet, Paris XV^e, 1961

22. Mimmo Rotella
Star, 1972-84

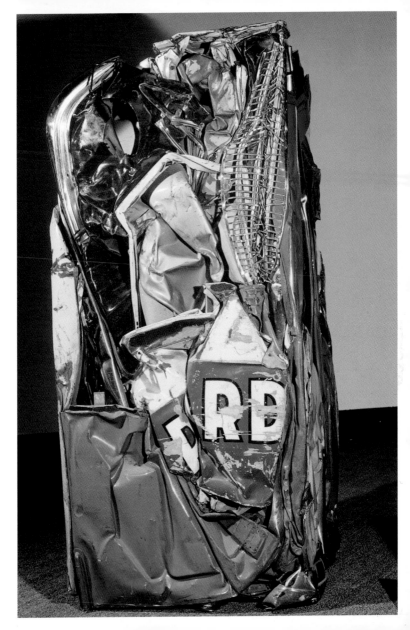

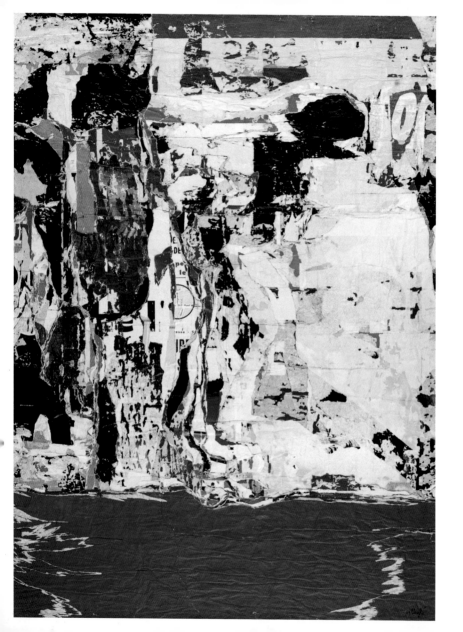

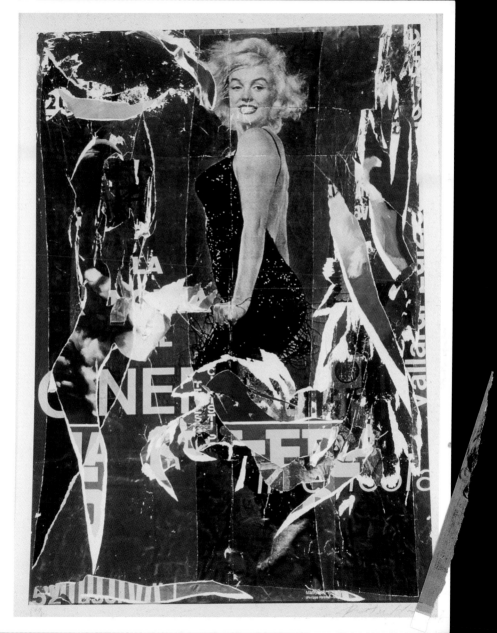

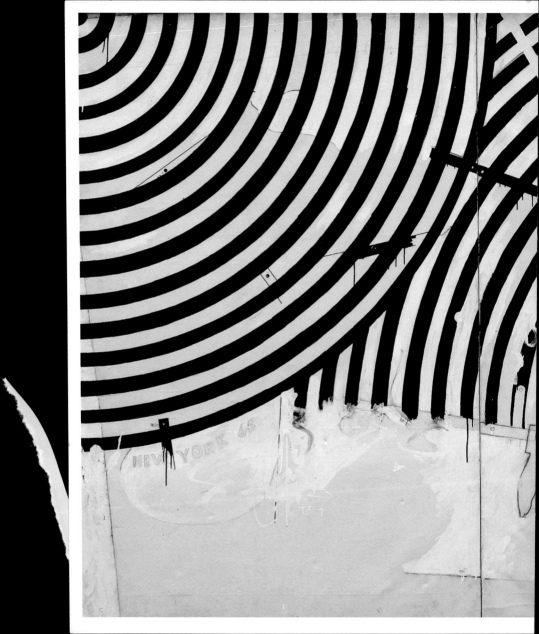

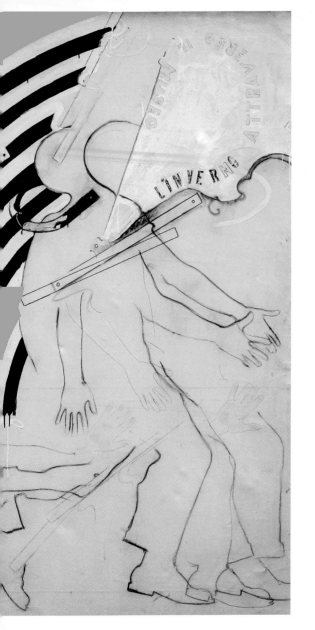

23. Mario Schifano
*L'inverno attraverso
il museo (Winter through
the Museum)*, 1965

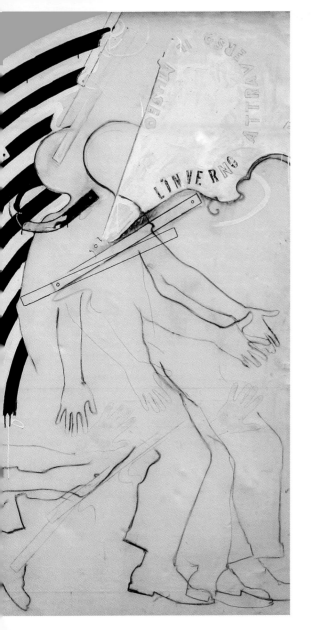

23. Mario Schifano
*L'inverno attraverso
il museo* (*Winter through
the Museum*), 1965

58

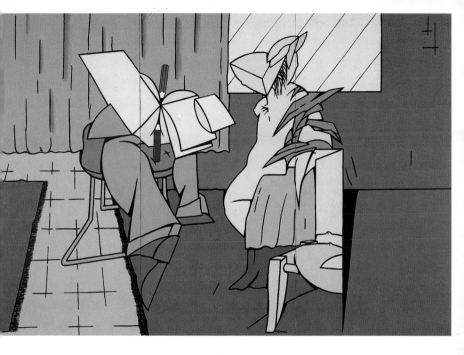

24. Mario Schifano
Bisogna farsi un'ottica
(*You Have to Get Yourself*
a Viewpoint), 1965

25. Valerio Adami
Henri Matisse che lavora
a un quaderno di disegni
(*Henri Matisse Working*
on a Copybook
of Drawings), 1966-67

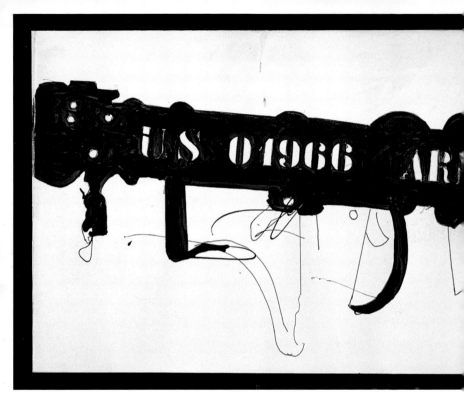

26. Franco Angeli
Bazooka, 1967

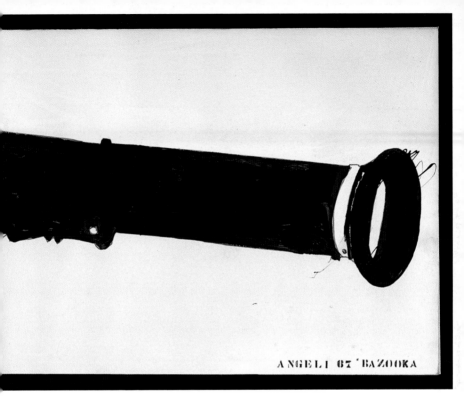

ANGELI 67 'BAZOOKA

61

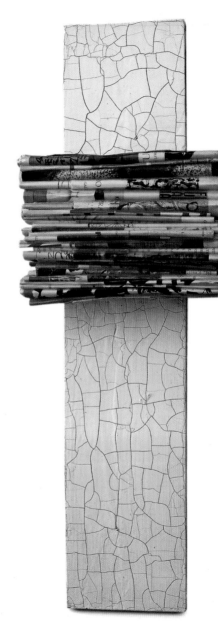

27. Gianfranco Baruchello
Micro salon doloricida (*Micro Painkilling Salon*), 1964

28. Domenico Gnoli
Cravatta (*Tie*), 1967

Following pages
29. Pino Pascali
Ricostruzione della balena (*Reconstruction of Whale*), 1966

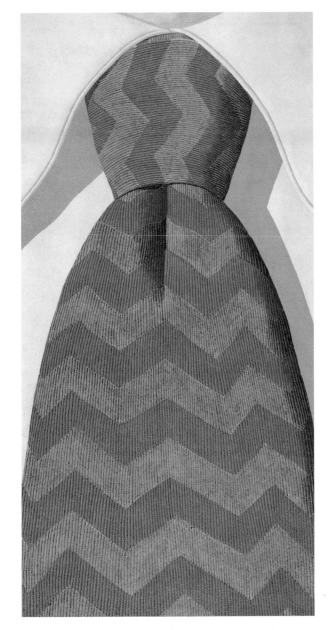

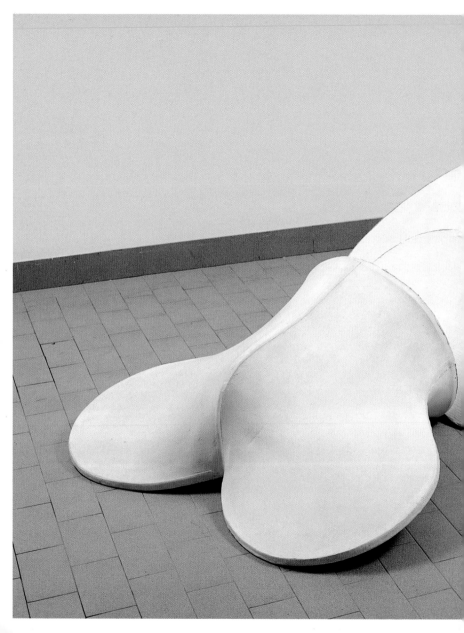

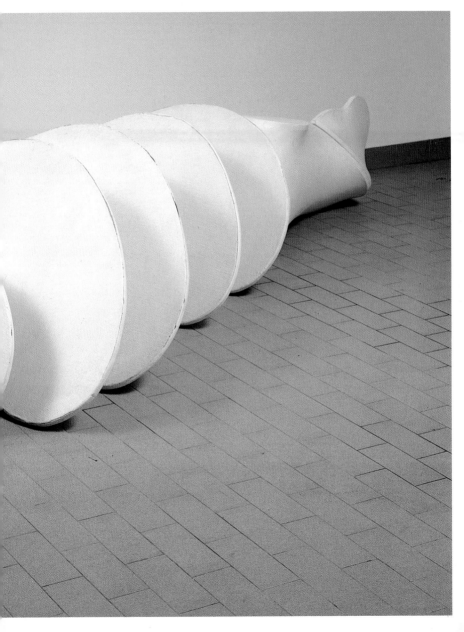

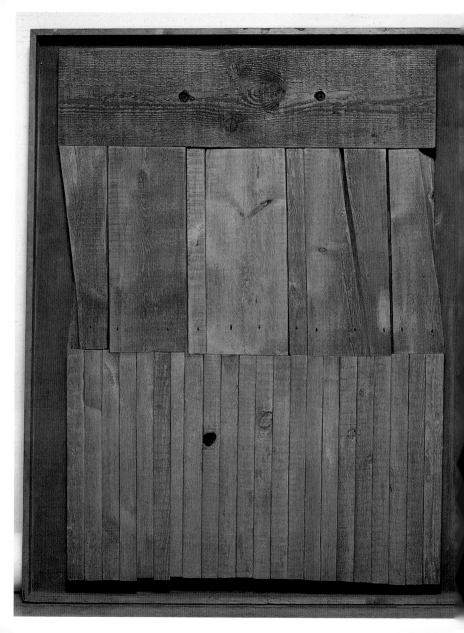

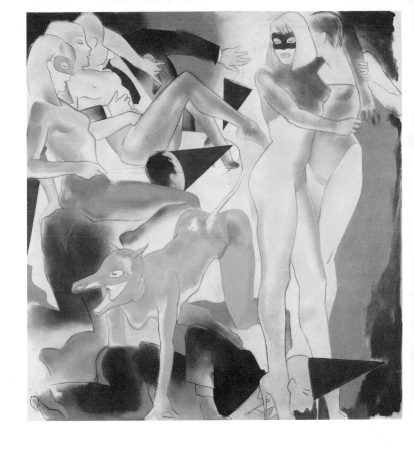

30. Joe Tilson
*Epistrophy – Wood
Relief No. 22*, 1961

31. Allen Jones
Encounter, 1984

32. Richard Hamilton
Trafalgar Square, 1965

33. Eduardo Paolozzi
Untitled, 1965

34. Peter Stämpfli
Rally, 1964

70

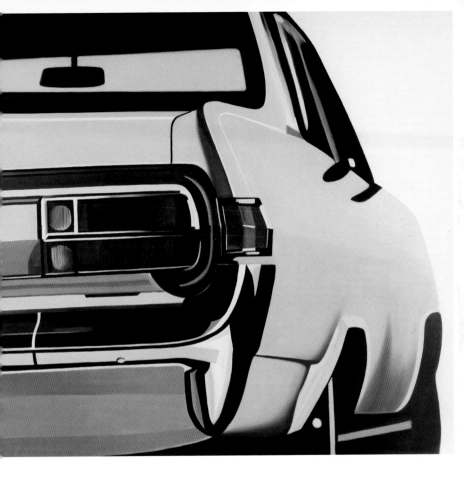

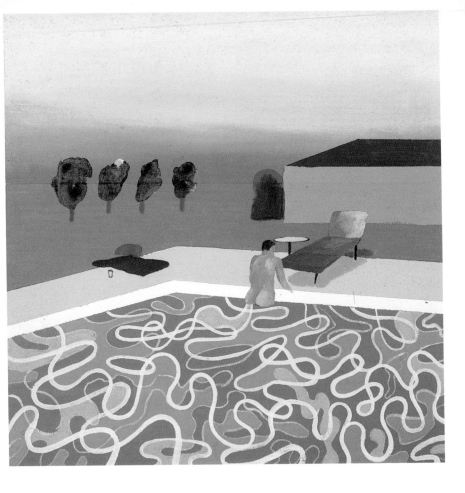

35. David Hockney
Swimming Pool, 1967

36. David Hockney
A Bigger Splash, 1967

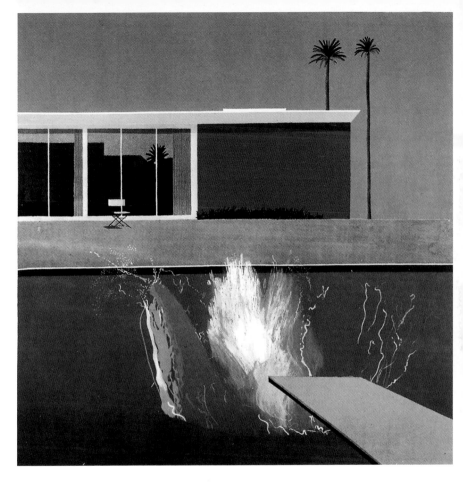

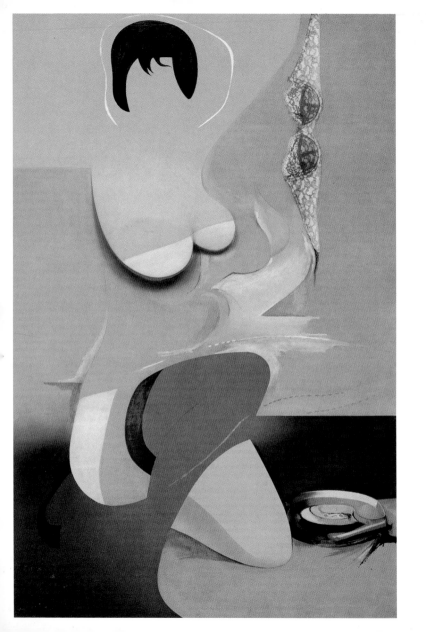

37. Richard Hamilton
Pin-up, 1961

38. Martial Raysse
Yellow Nude, 1964

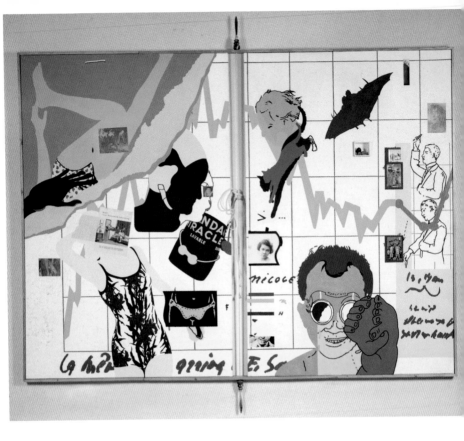

39. Hervé Télémaque
Convergence, 1966

40. Bernard Rancillac
The Last Whisky, 1966

Following pages
41. Martial Raysse
*Hygiene of a vision
(Double Portrait)*, 1968

42. Jacques Monory
Adriana No. 2, 1970

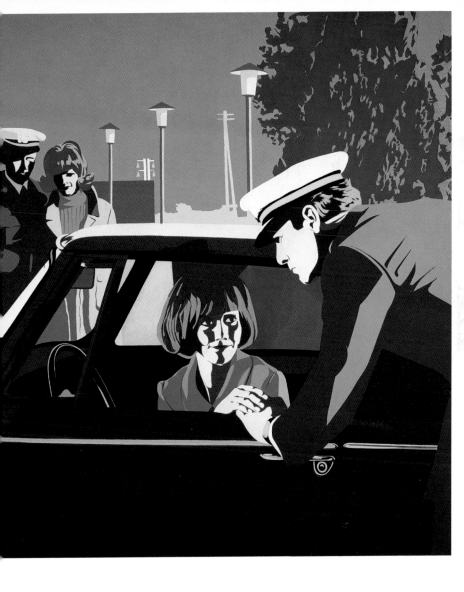

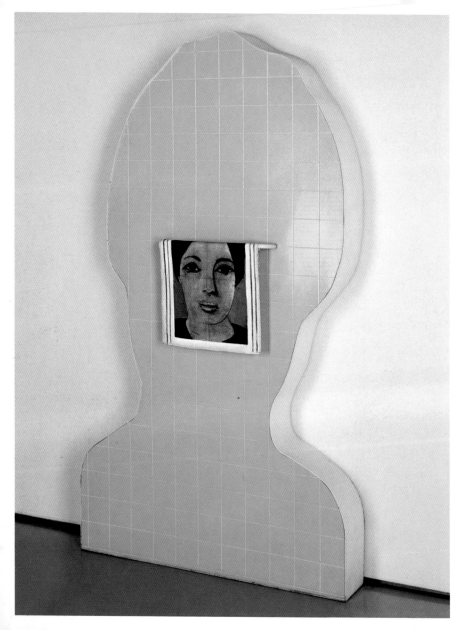

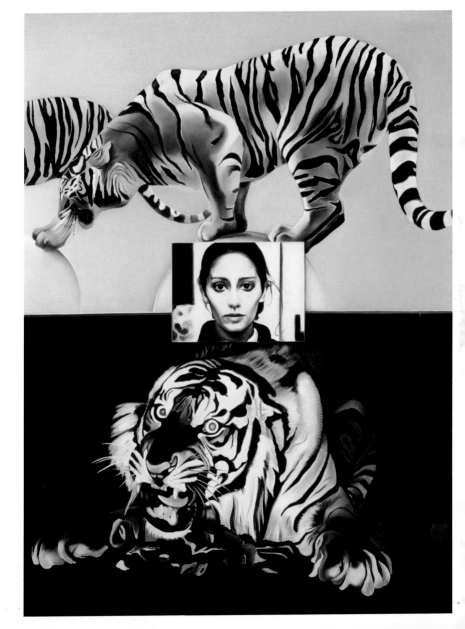

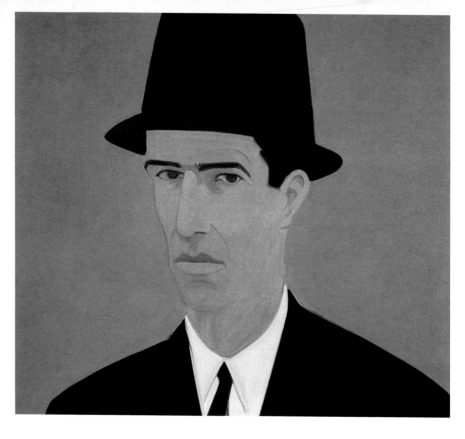

43. Alex Katz
Passing, 1962-63

44. Chuck Close
Self-portrait, 1977

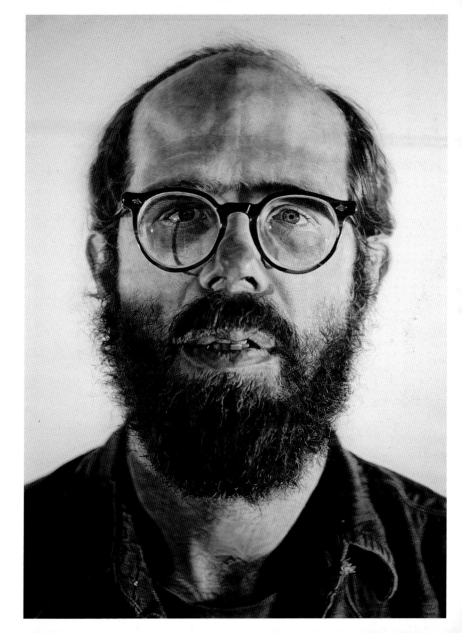

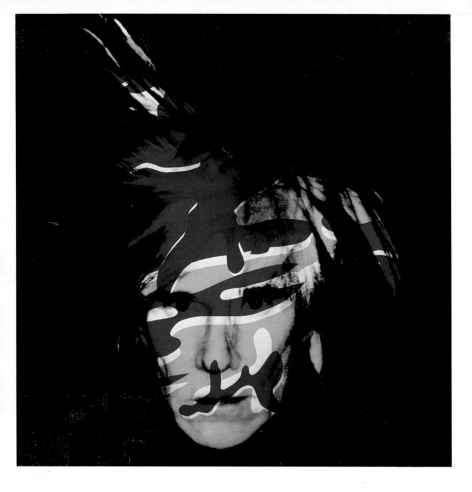

45. Andy Warhol
Self-portrait, 1986

46. Andy Warhol
Self-portrait (Fight Wig),
1986

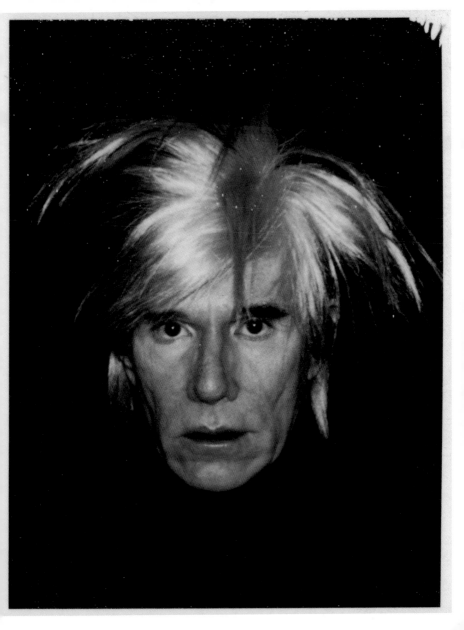

Appendix

Catalogue
of the Works

1. Jasper Johns
Flag, 1954-55
Encaustic, oil and collage
on fabric mounted on
plywood, 107.3 x 154 cm
The Museum of Modern
Art, New York
Gift of Philip Johnson in
honour of Alfred H. Barr Jr.

**2. Robert
Rauschenberg**
Kite, 1953
Oil and silkscreen ink
on canvas, 213 x 152 cm
MART (Museo d'Arte
Contemporanea di Trento
and Rovereto), Rovereto

**3. Robert
Rauschenberg**
Bed, 1955
Oil and pencil on pillow,
quilt and sheet on wooden
supports,
191.1 x 80 x 20.3 cm
The Museum of Modern
Art, New York
Gift of Leo Castelli in
honour of Alfred H. Barr Jr.

4. Jim Dine
Ties, 1961
Oil and graphite on paper,
45.5 x 61 cm
Luigi and Peppino Agrati
Collection

**5. Robert
Rauschenberg**
Blue Exit, 1961
Combine painting on
canvas, 213.5 x 153.5 cm
Luigi and Peppino
Agrati Collection

6. James Rosenquist
I Love You with My Ford,
1961
Oil on canvas,
210.2 x 237.5 cm
Moderna Museet,
Stockholm

7. James Rosenquist
Blue Spark, 1962
Mixed media on canvas,
121.5 x 152.5 x 42.5 cm
IVAM (Instituto Valenciano
de Arte Moderno),
Valencia

8. Tom Wesselmann
Still Life #30, 1963
Oil, enamel and synthetic
polymer paint
on composition board
with collage of printed
advertisements, plastic
flowers, refrigerator door,
plastic replicas of 7-Up
bottles, glazed and framed
color reproduction,
and stamped metal,
122 x 167.5 x 10 cm
The Museum of Modern
Art, New York
Gift of Philip Johnson

9-10. Robert Indiana
Eat/Die, 1962
Oil on canvas, diptych,
182.8 x 152.3 cm
Private collection
Courtesy Simon
Salama-Caro

11. Andy Warhol
Jackie, 1964
Acrylic and silkscreen ink
on linen, 50.8 x 40.6 cm
The Andy Warhol Museum,
Pittsburgh

12. Andy Warhol
Four Marilyns, 1962
Silkscreen ink on synthetic
polymer paint on canvas,
76.2 x 61 cm
Private collection

13. Tom Wesselmann
Mouth, 7, 1966
Oil on shaped canvas,
206.3 x 165.1 cm
The Museum of Modern
Art, New York
Sidney and Harriet Janis
Collection

14. Claes Oldenburg
*Lipstick (Ascending)
on Caterpillar Tracks*
(detail), 1969-74
Cor-Ten steel, steel,
aluminium and cast resin,
painted with polyurethane
enamel,
7.16 x 7.58 x 3.33 m
Samuel F.B. Morse
College, Yale University,
New Haven

15. Mel Ramos
Miss Fruit Salad, 1965
Oil on canvas,
152.4 x 127 cm
Courtesy Galleria d'Arte
Maggiore – GAM Bologna

16. Roy Lichtenstein
Girl with Ball, 1961
Oil and synthetic polymer
paint on canvas,
153 x 91.9 cm
The Museum of Modern
Art, New York
Gift of Philip Johnson

17. Roy Lichtenstein
*Yellow and Green
Brushstrokes*, 1966
Oil and magna (acrylic)
on canvas, 214 x 458 cm
Museum für Moderne
Kunst, Frankfurt

18. Robert Indiana
LOVE, 1967
Screen-print,
86.3 x 86.3 cm
The Museum of Modern
Art, New York

19. Roy Lichtenstein
*Modern Painting; Mochen
Pointiny*, 1967
Oil and magna (acrylic)
on canvas, 61 x 61 cm
Luigi and Peppino Agrati
Collection

**20. César Baldaccini
called César**
Compression "Ricard",
1962
Manipulated compression
of the chassis of a car,
153 x 73 x 65 cm
Musée National d'Art
Moderne – Centre
Georges Pompidou, Paris

**21. Jacques
de La Villeglé**
*Avenue de La Motte-
Picquet, Paris XV*, 1961
Paint on décollage,
131 x 96.5 cm
Musée d'Art Moderne,
Saint-Etienne Métropole

22. Mimmo Rotella
Star, 1972-84
Paint on décollage,
131 x 96.5 cm
Private collection

23. Mario Schifano
*L'inverno attraverso il
museo* (*Winter through
the Museum*), 1965
Enamel paint on paper
mounted on canvas,
220 x 300 cm
Private collection

24. Mario Schifano
Bisogna farsi un'ottica
(*You Have to Get Yourself
a Viewpoint*), 1965
Mixed media on canvas,
160 x 300 cm
Giorgio Marconi Collection,
Milan

25. Valerio Adami
*Henri Matisse che lavora
a un quaderno di disegni*
(*Henri Matisse Working
on a Copybook
of Drawings*), 1966-67
Acrylic on canvas,
200 x 300 cm
Giorgio Marconi Collection,
Milan

26. Franco Angeli
Bazooka, 1967
Oil, acrylic, felt-tip pen on
paper covered with fabric,
50 x 140 cm
Luigi and Peppino Agrati
Collection

**27. Gianfranco
Baruchello**
Micro salon doloricida
(*Micro Painkilling Salon*),
1964
Collage on plastic,
92 x 30 x 12 cm
Private collection

28. Domenico Gnoli
Cravatta (*Tie*), 1967
Acrylic on canvas,
174 x 90 cm
Private collection

29. Pino Pascali
Ricostruzione della balena
(*Reconstruction of Whale*),
1966
Canvas stretched over
wooden ribs, 366 cm
(8 elements)
Luigi and Peppino Agrati
Collection

30. Joe Tilson
*Epistrophy – Wood Relief
No. 22*, 1961
Assemblage of pieces
of wood, 152.5 x 122 cm
Private collection

31. Allen Jones
Encounter, 1984
Oil on canvas,
244 x 234 cm
Collection of the artist,
London

32. Richard Hamilton
Trafalgar Square, 1965
Oil and acrylic on wood,
40.5 x 61 cm
Giorgio Marconi Collection,
Milan

33. Eduardo Paolozzi
Untitled, 1965
Chromium-plated steel,
61 x 102 x 61 cm
Giorgio Marconi Collection,
Milan

34. Peter Stämpfli
Rally, 1964
Oil on canvas,
173 x 188 cm
Musée d'Art Moderne,
Saint-Etienne Métropole

35. David Hockney
Swimming Pool, 1967
Oil on canvas, 60 x 60 cm
Giorgio Marconi Collection,
Milan

36. David Hockney
A Bigger Splash, 1967
Acrylic on canvas,
242.5 x 243.9 cm
Tate Gallery, London

37. Richard Hamilton
Pin-up, 1961
Oil, cellulose and collage
on panel,
cm 121,9 x 81,3 x 7,6
The Museum of Modern
Art, New York
Enid A. Haupt Fund
and an anonymous fund

38. Martial Raysse
Yellow Nude, 1964
Acrylic and oil on plywood,
96.5 x 130 cm
Luigi and Peppino Agrati
Collection

39. Hervé Télémaque
Convergence, 1966
Acrylic on canvas, collage
and skipping rope,
198 x 273 cm
Musée d'Art Moderne,
Saint-Etienne Métropole

40. Bernard Rancillac
The Last Whisky, 1966
Vinyl paint on canvas,
225 x 200 cm
Musée d'Art Moderne,
Saint-Etienne Métropole

41. Martial Raysse
*Hygiene of Vision
(Double Portrait)*, 1968
Metal and panolac paint
with silkscreen ink on
cloth, 200 x 110 x 30 cm
Musée d'Art Moderne,
Saint-Etienne Métropole

42. Jacques Monory
Adriana No. 2, 1970
Oil on canvas,
203.5 x 151.1 cm
Musée d'Art Moderne,
Saint-Etienne Métropole

43. Alex Katz
Passing, 1962-63
Oil on canvas,
182.2 x 202.2 cm
The Museum of Modern
Art, New York
Gift of the Louis and
Bessie Adler Foundation,
Inc., Seymour M. Klein

44. Chuck Close
Self-portrait, 1977
Watercolour on paper
mounted on canvas,
205 x 149.2 cm
MUMOK (Museum
Moderner Kunst Stiftung
Ludwig), Vienna

45. Andy Warhol
Self-portrait, 1986
Acrylic and silkscreen
ink on canvas,
101.6 x 101.6 cm
The Andy Warhol Museum,
Pittsburgh

46. Andy Warhol
*Self-portrait
(Fight Wig)*, 1986
Acrylic and silkscreen
ink on canvas,
101.6 x 101.6 cm
The Andy Warhol Museum,
Pittsburgh

	Events in the Arts	**Historical events**

1954

Jasper Johns works with his first flags, Robert Rauschenberg evolves from his roots in Dada and Surrealism. The following year the term Pop Art, an abbreviation of popular art, is used for the first time by Leslie Fiedler and Reyner Banham.

The first programme of mass vaccination, against poliomyelitis, is carried out in Pittsburgh. Conquest of the peak of K2. The first colour television sets go on sale in the US, while in Italy the RAI starts its broadcasts.

1956

An exhibition of the work of Domenico Gnoli is staged in New York, heralding the advent of Pop Art. In London the exhibition *This is Tomorrow* opens, presenting the new tendency in British art.

Nikita Khrushchev denounces the crimes of Stalin. John Lennon and Paul McCartney meet for the first time, while the decade-long partnership between Dean Martin and Jerry Lewis comes to an end.

1958

Lawrence Alloway calls the new development in Britain "Pop Art". Rauschenberg and Jasper Johns hold solo exhibitions at Leo Castelli's, in New York. On the opening day of Johns' show the MoMA buys four of his works, while another is quickly sold at the price of a million dollars.

The article "The Arts and the Mass Media" comes out in Architectural Design. Two years later a monochrome by Klein, one of Tinguely's machines and Hains' torn advertising posters will be shown at the Paris Biennale, while in the US Kaprow will inaugurate the practice of the happening.

1961

The *Young Contemporaries* exhibition opens at the RBA Galleries in London. The exhibitions *40° au-dessus de Dada* and *Le Nouveau Réalisme à Paris et à New York* are staged in Paris. Oldenburg opens *The Store*, where mock products are presented in a real shop. Martha Jackson's show *Environments, Situations, Spaces* opens.

Eisenhower breaks off diplomatic relations between the US and Cuba and Kennedy, elected shortly afterwards, authorizes the landing in the Bay of Pigs. Yuri Gagarin becomes the first man in space. Leonard Kleinrock publishes a proposal for his thesis on message switching, the precursor of the technique of packet switching on which the internet will be based. The Beatles stage their first concert at the Cavern Club in Liverpool.

1962

Exhibitions by Rosenquist, Segal, Oldenburg and Wesselmann are held at the Green Gallery. Sidney Janis organizes *New Realists*, comparing American and European artists.

Tragedy at Orly airport. The Beatles' first single and the first James Bond film come out in Britain. Cuban missile crisis.

88

Events in the Arts	Historical events
1964 The Venice Biennale proclaims Rauschenberg the father of Pop Art.	The Nobel Peace Prize goes to Martin Luther King. The Gulf of Tonkin Incident brings an escalation in the Vietnam War.
1965 Warhol shows the second series of *Flowers* and a first American retrospective of his work is held in Philadelphia. The Velvet Underground frequents the Factory. The MoMA in New York devotes an exhibition to Optical Art.	Malcolm X is assassinated in Harlem. First American bombing raids on North Vietnam. A space probe reaches Mars for the first time. The Doors and Pink Floyd are formed.
1967 Warhol produces the album *The Velvet Underground & Nico*. Sol LeWitt coins the term "Conceptual Art". Peter Blake designs the cover of the Beatles' *Sgt. Pepper's Lonely Hearts Club Band*.	The Peace March is held in Washington. Marshall McLuhan publishes *The Medium is the Message*. The musical *Hair* opens.
1968 The Factory moves to 33 Union Square. The Moderna Museet in Stockholm puts on Warhol's first European retrospective, which travels to other venues. The same year he is shot and wounded by Valerie Solanas.	Martin Luther King and Robert Kennedy are assassinated. Student protest breaks out in Europe. Duchamp dies. Stanley Kubrick's *2001: A Space Odyssey* is released.
1970 The Pasadena Art Museum stages a retrospective of Warhol, who the following year will design the cover of the Rolling Stones' album *Sticky Fingers*, among others. Robert Smithson creates the *Spiral Jetty*.	The Beatles' *Let It Be*.
1973 Warhol makes *Morrissey Flesh for Frankenstein* and *Blood for Dracula*, produced by Carlo Ponti. Picasso dies.	The war in Vietnam ends. *Coup d'état* in Chile supported by the CIA.
1977 Punk rock is born: Warhol is considered its precursor. The artist photographs celebrities at Studio 54.	Elvis Presley dies.

Biographies
of the main Artists

Roy Lichtenstein

(New York, 1923 – 1997)
Born in New York in 1923. In the early forties he attended Ohio State University and classes at the Art Students League in New York, where he studied under Reginald Marsh. In 1943 he was conscripted and sent to Europe; he returned three years later and resumed his studies, following the painting courses taught by Hoyt Sherman and the graduate programme in Fine Arts; his first solo exhibition, held in 1951 at the Carlebach Gallery in New York, was followed immediately by an exhibition at the John Heller Gallery. Lichtenstein was also a window-dresser and designer, and made technical drawings for Republic Steel. One of his early works, the 1956 lithograph *Ten Dollar Bill*, was a presage of Pop Art. The following year he became an assistant at the State University of New York, Oswego, and then went on to teach at Douglass College in New Jersey.
Leo Castelli's gallery handled his work; the artist came into contact with some of the most innovative people of the time, such as Oldenburg, Segal, Kaprow and several members of the experimental group Fluxus (…).
In 1963 he showed in Paris, at Ileana Sonnabend's, and was commissioned to paint a mural for the New York State Pavilion at the World's Fair. In 1966 he took part in the Venice Biennale for the first time and held a solo exhibition at the Museum of Modern Art in Cleveland. In 1967 a retrospective of his work was held at the Pasadena Art Museum, from where it moved to Europe. The following year he showed at Documenta in Kassel, and in 1969 another solo exhibition was organized at the Guggenheim in New York.
In 1970 he painted a mural for the Faculty of Medicine at Düsseldorf University; he also showed at the Museum of Contemporary Art in Chicago and the Seattle Art Museum, and moved to Southampton, Long Island. In 1972 he had an exhibition at the Contemporary Art Museum in Houston, in 1975 at the Centre National d'Art Contemporain in Paris and in 1978 at the Institute of Contemporary Art in Boston. In 1984 the artist opened a studio in New York, shortly before the work for the Equitable Tower in Manhattan and the *Salute to Painting* for the Walker Art Center.
In 1992 he designed a sculpture for the Olympics in Barcelona. A year later the Guggenheim in New York organized an exhibition which then went on to Los Angeles, Montreal, Munich, Hamburg and Brussels. Later he showed at the National Gallery of Art in Washington. His last sculpture, *Singapore Brushstroke*, dates from 1994.
After donating many works to the National Gallery, Lichtenstein died in New York in 1997.

George Segal

(New York, 1924 – New Brunswick, 2000)
He was born in New York into a family of European Jews who owned a butcher's in the Bronx but soon decided to move to New Jersey to raise poultry. In his adolescence the artist spent a great deal of time helping his parents and then went to stay with an uncle in Brooklyn to attend the Stuyvesant Technical High School. It

was during his years at university that he became interested in art. He got to know many artists, especially experimental ones working in the figurative sphere: in the same period he became involved in the 10th Street scene. In 1946, after his marriage, Segal bought a chicken farm of his own and taught English and art at the local high school and at Rutgers.

His passion for painting grew to the point where he embarked on a collaboration with the Hansa Gallery in 1956, showing pictures there. In 1957 he took part in the exhibition *Artists of the New York School: Second Generation* at the Jewish Museum in New York.

In 1958 Allan Kaprow chose Segal's chicken farm as the location for a happening. The following year Segal began to produce sculpture himself, showing it in a solo exhibition at the Green Gallery in 1960. In 1961, while he was teaching in New Brunswick, a student brought a box of dry plaster bandages to class; Segal began to experiment with their ductility, creating a cast of his own seated body. Then he added a setting: a chair, a window frame and a table. Out of this came *Man Sitting at a Table*, the first of a long series of innovative tableaux for which he used friends and relatives as models. In his last years the artist utilized photographs as the basis for creating sculptures and drawings, remaining active up until his death in New Brunswick in 2000.

Robert Rauschenberg

(Port Arthur, 1925 – Captiva Island, Florida, 2008)

He was born in Texas. Initially he studied pharmaceutics at university, but then enrolled in the Marines. In the second half of the forties he took some courses at the Kansas City Art Institute, before moving to Paris and attending the Académie Julian. Returning to the US, the artist studied under Joseph Albers at the Black Mountain College, where he met John Cage and Merce Cunningham. From 1949 to 1952 he lived in New York, where he set up a studio: he earned a living dressing windows (Tiffany's was one of his clients), enrolled in the Art Students League and in 1951 staged his first solo exhibition at the Betty Parsons Gallery. In 1952 he went back to North Carolina and taught at the Black Mountain College; he staged the first happening with Cage and made numerous journeys.

From 1954 to 1965 he worked with Cunningham's dance company. In 1955 he created the first combine paintings. In 1958 he showed at Leo Castelli's. From the end of the fifties he began to participate in events like Documenta in Kassel and the Biennials in Paris and São Paulo. In the sixties he met Duchamp and started to make increasing use of collage and lithography. He showed at the Galerie Sonnabend in Paris, the Jewish Museum in New York, the Whitechapel Gallery in London and the Venice Biennale, where he won the Grand Prize for Painting. He also exhibited at the MoMA, in Amsterdam and in Cologne.

He set up, with Billy Klüver, the non-profit organization Experiments in Art and Technology (EAT). In the eighties he launched the Rauschenberg Overseas Cultural Interchange project to promote collaboration between artists from different parts of the world; over the same period he concentrated on sculpture, working in metal as well, and designed scenes and costumes for theatrical productions. With the passing of the years he went on showing his works at the world's principal galleries and most important museums.

Andy Warhol

(Pittsburgh, 1928 – New York, 1987)
He was born in Pittsburgh in 1928, to a family of Slovakian immigrants. He studied at the Carnegie Institute of Technology and after graduating moved to New York, where he worked as a set designer and commercial artist, contributing to magazines like *Glamour*, *Harper's Bazaar* and *Vogue*. In 1952 he held his first solo exhibition at the Hugo Gallery, followed over the same decade by an exhibition of drawings at the Bodley Gallery, the presentation of the *Golden Shoes* in Madison Avenue and numerous journeys. In the sixties the artist began to concentrate on paintings, using the technique of silk-screen printing in particular, and laid the foundations of American Pop Art through his choices of imagery. The great interest shown in this artistic avant-garde for the masses turned him into a sort of entrepreneur: he set up the Factory and his works were exhibited at important venues (Castelli's in New York, Sonnabend's in Paris, the Institute of Contemporary Art in Philadelphia, the Moderna Museet in Stockholm). Warhol was very interested in the cinema and started to experiment with the medium, even making a number of full-length films in a fertile collaboration with Paul Morrissey. He published the book *a: A Novel* and founded the magazine *Interview* in 1969. Transcriptions of his conversations were published as *The Philosophy of Andy Warhol (From A to B & Back Again)* in 1975. He also had close ties with musicians: in 1967 he adopted Lou Reed and the Velvet Underground, financing their first record and designing its cover. In 1979 the Whitney Museum brought many of his famous portraits together in *Andy Warhol: Portraits of the 70s*. In 1980 he produced the television show *Andy Warhol's TV*. In his later years be became interested in revisiting works of the past and collaborated creatively with Francesco Clemente and Jean-Michel Basquiat. He died in New York in February 1987, while recovering from routine surgery.

Claes Oldenburg

(Stockholm, 1929)
He was born in Stockholm in 1929 but spent most of his childhood in the United States. He studied at Yale University and the Art Institute of Chicago, and in 1956 moved to New York. In the early sixties he opened *The Store*, a singular shop filled with plaster reproductions of items of food, and in particular the protagonists of the new range of American consumer products, such as hamburgers, ice cream and hot dogs, which he also began to create on a gigantic scale, using foam rubber and vinyl.
In the same period he designed environments and installations, and played a leading role in numerous happenings. The subjects of his works were strongly linked to pop culture in a New Dada key and, in an ironic emphasis of mass society, often perfunctorily coloured or finished in an imprecise way. From 1976 on Oldenburg collaborated creatively with Coosje van Bruggen, with whom he had already realized more than forty colossal site-specific projects: these were deformations of the real scale, playful exaggerations located around the world. They ranged from a blue trowel planted in the ground at the Rijksmuseum in Otterlo to the clothes peg in Philadelphia or the baseball bat that travelled from New Haven to Chicago; from the billiard balls in Münster to the spectacular performance in Venice entitled *The Course of the Knife*.

92

Jasper Johns

(Augusta, 1930)

Jasper Johns was born in Georgia to parents who had separated and grew up in South Carolina. In 1952, to escape a difficult family situation and the cultural constraints of his environment, he moved to New York, where he took a course in art. He joined the army and was sent to Japan, returning to the US in 1954. He then began to work in a bookshop and, like Rauschenberg – whom he had just met and who had become his neighbour – on the decoration of windows at Tiffany's. In 1957 he took part in the exhibition *Artists of the New York School: Second Generation*, organized by Meyer Shapiro for the Jewish Museum. In 1958 Leo Castelli put on a solo exhibition of Johns' work at his gallery; subsequently the MoMA bought some of his works and he showed at the Venice Biennale. He won the Carnegie Prize at the Biennial in Pittsburgh and exhibited in major European cities. Johns worked with Allan Kaprow, Merce Cunningham and John Cage, as well as with Universal Limited Art Editions. He took part in the exhibitions *Le Nouveau Réalisme à Paris et à New York* at the Galerie Rive Droite in Paris and *American Painting in the Twentieth Century* at the Metropolitan Museum of Art in New York. His works have been seen shown at the Guggenheim and at the Whitechapel Art Gallery in London, at the Biennali of Venice and São Paulo and at Documenta in Kassel.

Tom Wesselmann

(Cincinnati, 1931 – New York, 2004)

He was born in Cincinnati, Ohio, in 1931. He studied psychology and in 1952, during the Korean War, was drafted into the army. After his discharge he studied at the Art Academy of Cincinnati and the Cooper Union School of Arts and Architecture in New York. At the same time he worked as a cartoonist for newspapers and taught at a high school in Brooklyn.

After showing an initial interest in Surrealism and Abstract Expressionism, he created a series of small collages towards the end of the fifties, beginning to develop a style of his own with fields of colour, later to be defined as "refined Pop". As early as the sixties he began to work on a number of series of pictures, such as *Bedroom Paintings*, *Smokers* and *Seascapes*, which occupied him until the eighties, and in the seventies, after the *Great American Nudes*, achieved great success with a more detached exploration of objects representative of mass society in the *Still Lifes*, drawn for the most part from roadside advertisements.

In 1961 he showed for the first time at the Tanager Gallery; the following year he took part in *The New Realists* at the Sidney Janis Gallery, where he held his first solo exhibition in 1966. The same year his work was shown at the Whitney Museum in *Young America*, where he returned to take part in *American Pop Art* in 1974. In 1980 he wrote a monograph entitled *Tom Wesselmann* under the pseudonym Slim Stealingworth.

From the mid-eighties he began to use a laser to cut his figures out of sheets of aluminium worked with coloured filigrees. In 1994 a solo exhibition of his work was held at the Kunsthalle in Tübingen. In 2004 he died of complications after heart surgery in New York.

David Hockney

(Bradford, 1937)

He was born into a large family in Bradford in 1937. At the age of eleven he went to Bradford Grammar School, where

he started to create drawings and posters. Later he enrolled in Bradford Art School and worked in a hospital as a conscientious objector. In 1959 he went to study at the Royal College of Art in London. Stimulated by friendships with artists like Kitaj, he took part in the 1961 exhibition *Young Contemporaries*, which had a fundamental influence on Pop Art in Britain. His discovery of the United States, and New York in particular, gave the artist a new sense of freedom, in his sexual life as well, that played a significant part in his artistic development. In 1964 he was invited to teach at the University of Iowa. The following year he gave lectures at Colorado University in Boulder. Shortly afterwards he decided to move to Los Angeles, where he found satisfaction on the professional (he sold well and showed at many venues, including solo exhibitions) as well as personal plane (in 1966 he met the nineteen-year-old Peter Schlesinger, who became his lover and model).

In 1968 he returned to England, where he held his first major solo exhibition at the Whitechapel Gallery.

In 1973 he moved temporarily to Paris, where he organized an exhibition at the Musée des Arts Décoratifs.

The following year he was the subject of Jack Hazan's fairly intimate and hard-hitting fictional film biography *A Bigger Splash*, which was a great success.

In the eighties the artist experimented with photographic collage, using a Polaroid camera and devices like the fax. Since the nineties he has continued with his research, showing a profound interest in more recent technology as well.

Selected Bibliography

M. Amaya, *Pop Art... and after*, New York 1965

M. Amaya, *Pop as art: a survey of the new super realism*, London 1965

D. Herzka, *Pop Art one*, New York 1965

E. Bailey, *Pop Art*, London 1976

H. Geldzahler, *Pop art 1955-70*, International Cultural Corporation of Australia, 1985

L. Lippard, *Pop Art*, New York 1985

M. Livingstone, *Pop Art, a continuing history*, New York 1990

C.J. Mamiya, *Pop Art and consumer culture: American super market*, Austin 1992

J. James, *Pop Art*, London 1996

S.H. Madoff (edited by), *Pop Art: a critical history*, Berkeley 1997

Pop Art: selections from the Museum of Modern Art, New York 1998

T. Osterwold, *Pop Art*, New York 1999

D. McCarthy, *Pop Art*, Cambridge 2000

S. Harrison, *Pop Art and the origins of post-modernism*, Cambridge 2001

H. Foster, J. Wilmerding, *Pop Art: Contemporary Perspectives*, Princeton 2007

MINI SKIRT
MINI SKIRT

POP ART
NOLESSE
GUGLPONI PLAM

OF 808052497G